IMAGINARY CREATURES
COLORING BOOK

Copyright © 2019 by Joel Nakamura

Published by
LEAF STORM PRESS
Post Office Box 4670
Santa Fe, New Mexico 87502
U.S.A.
leafstormpress.com

To inquire about bulk discounts for special events, promotions and premiums
please contact the publisher by email at leafstormpress@gmail.com.

Printed in the U.S.A.

Book Design by LSP Graphics
Design Consultant: Jack Dudzik

ISBN 978-1-9456520-2-8

10 9 8 7 6 5 4 3 2

PLEASE NOTE THAT IF USING MARKERS OR INK PENS
WE RECOMMEND INSERTING A PIECE OF THICK PAPER
BETWEEN COLORING PAGES TO PREVENT BLEED THROUGH.

IMAGINARY CREATURES
COLORING BOOK

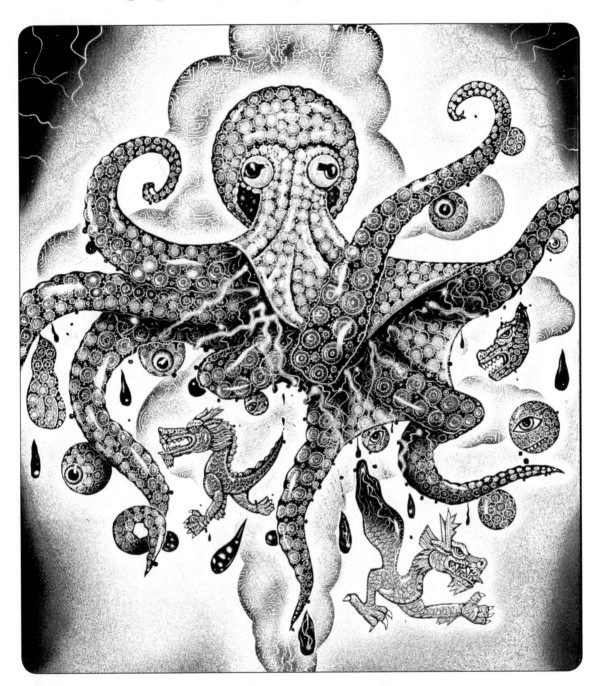

JOEL NAKAMURA

LeafStormPress

SANTA FE, NEW MEXICO

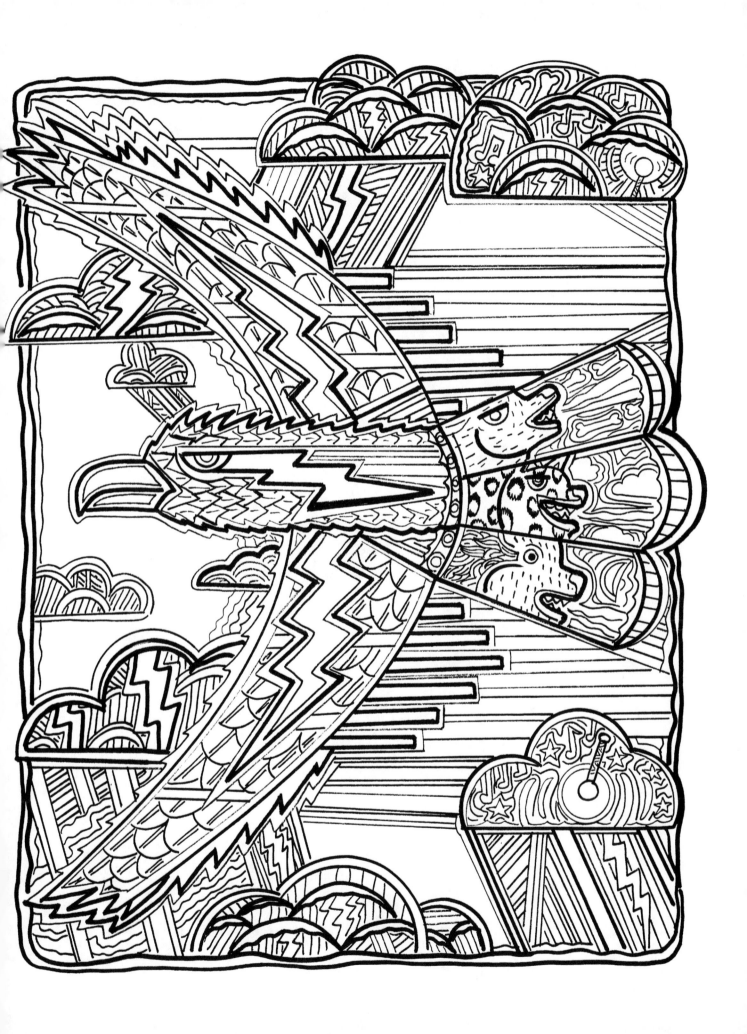

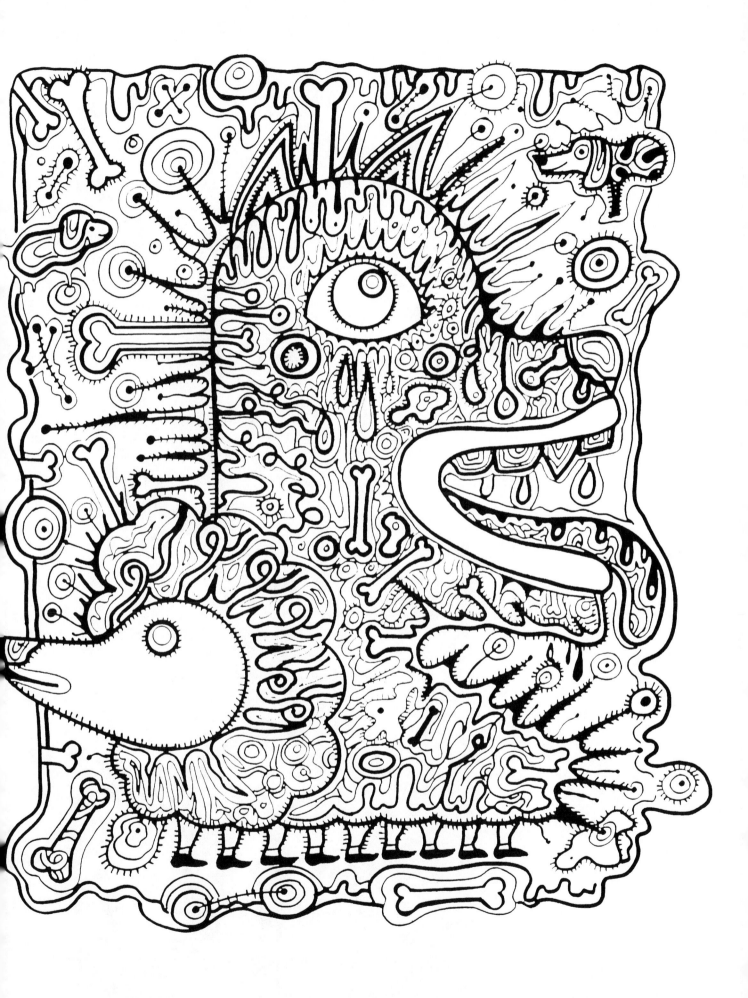

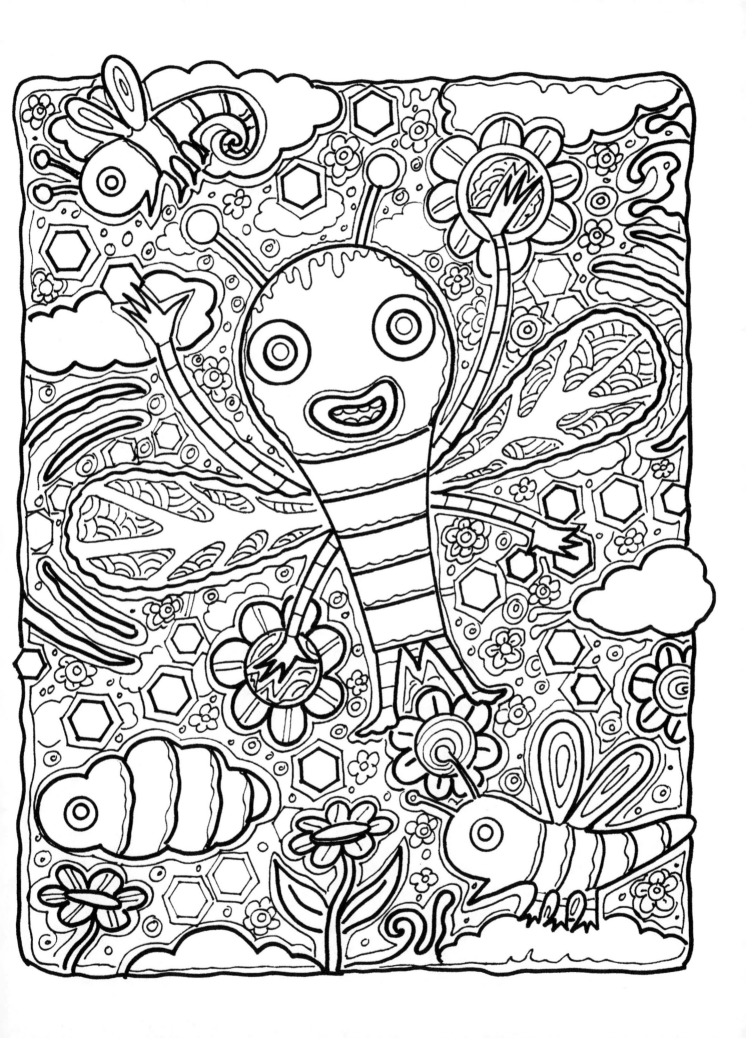

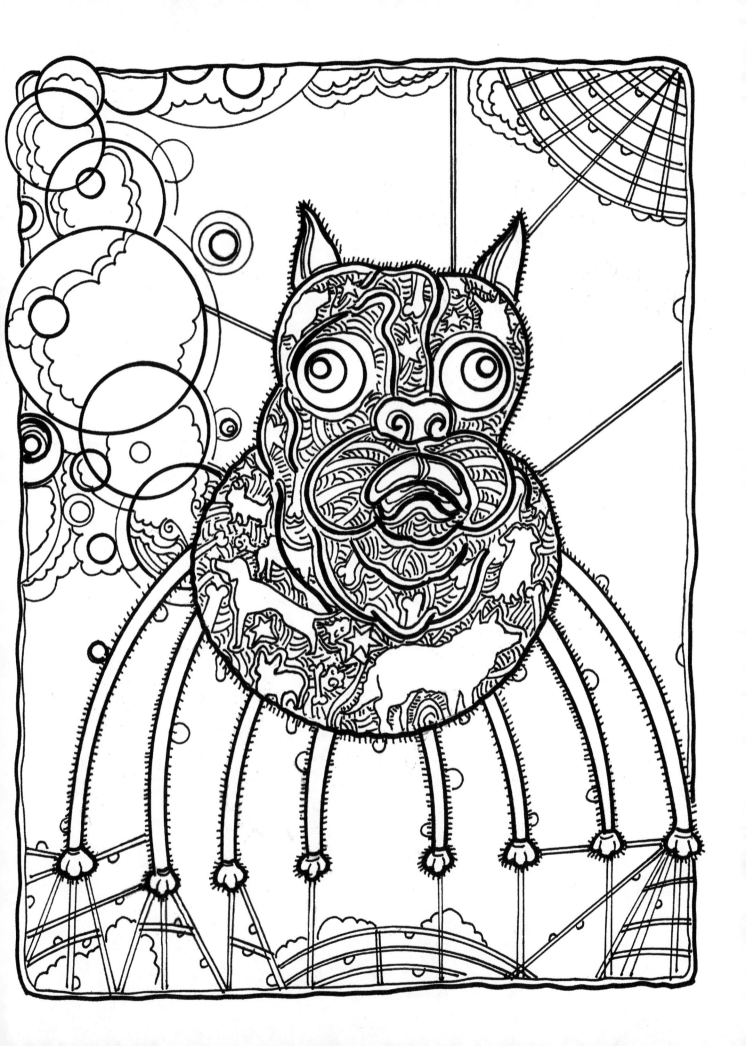

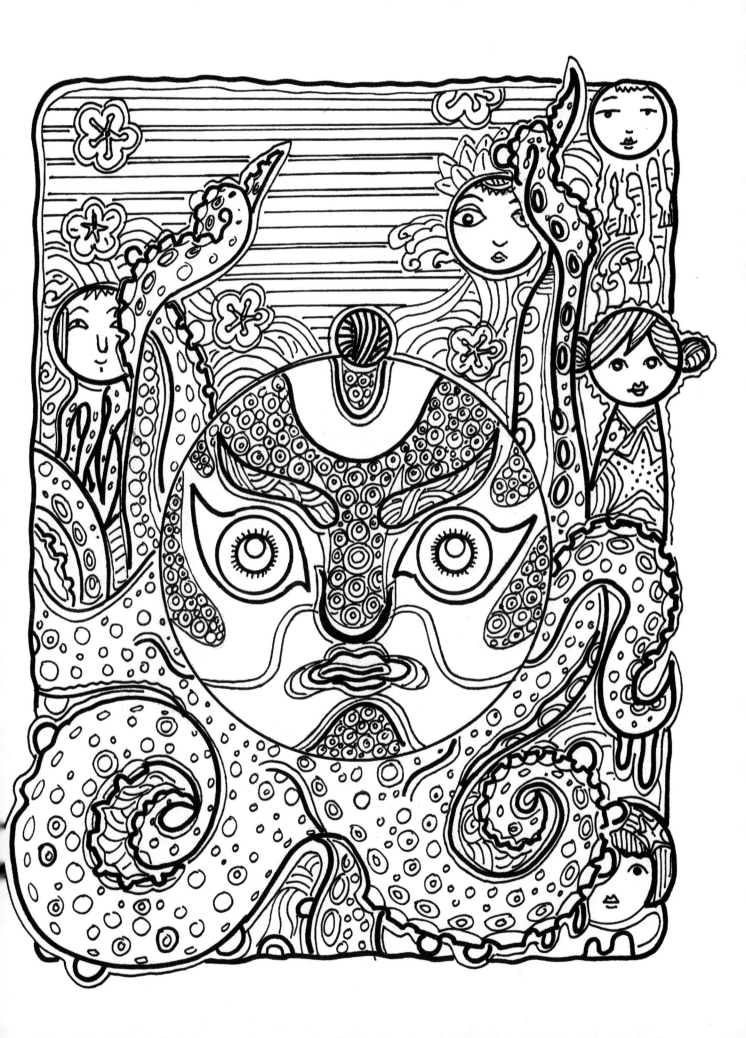

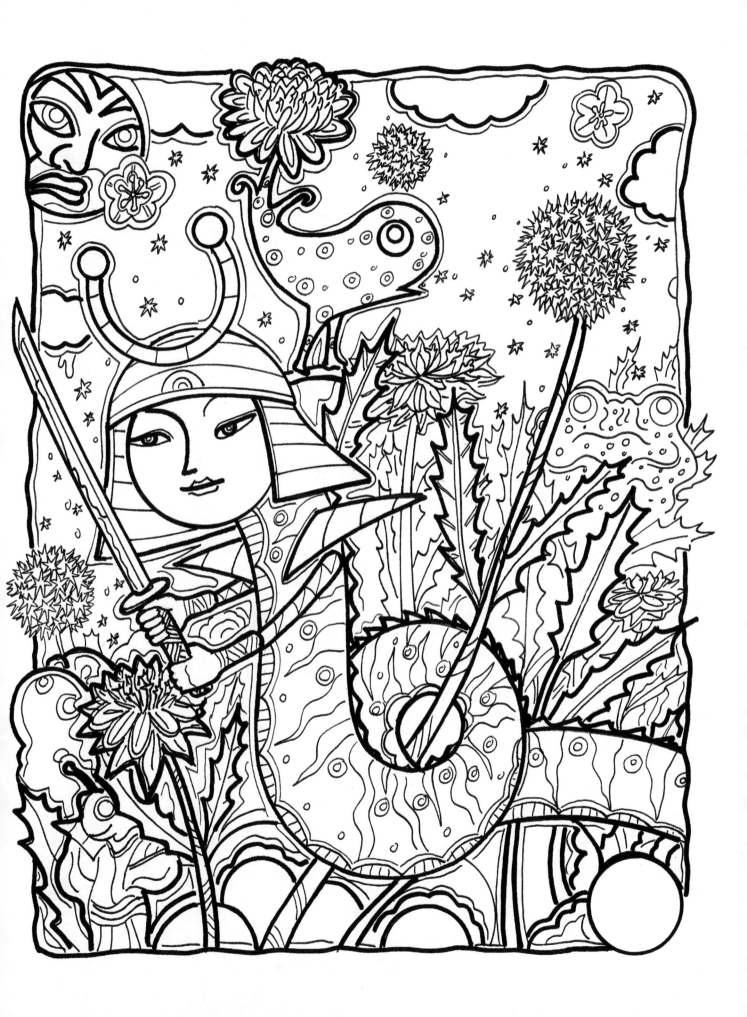

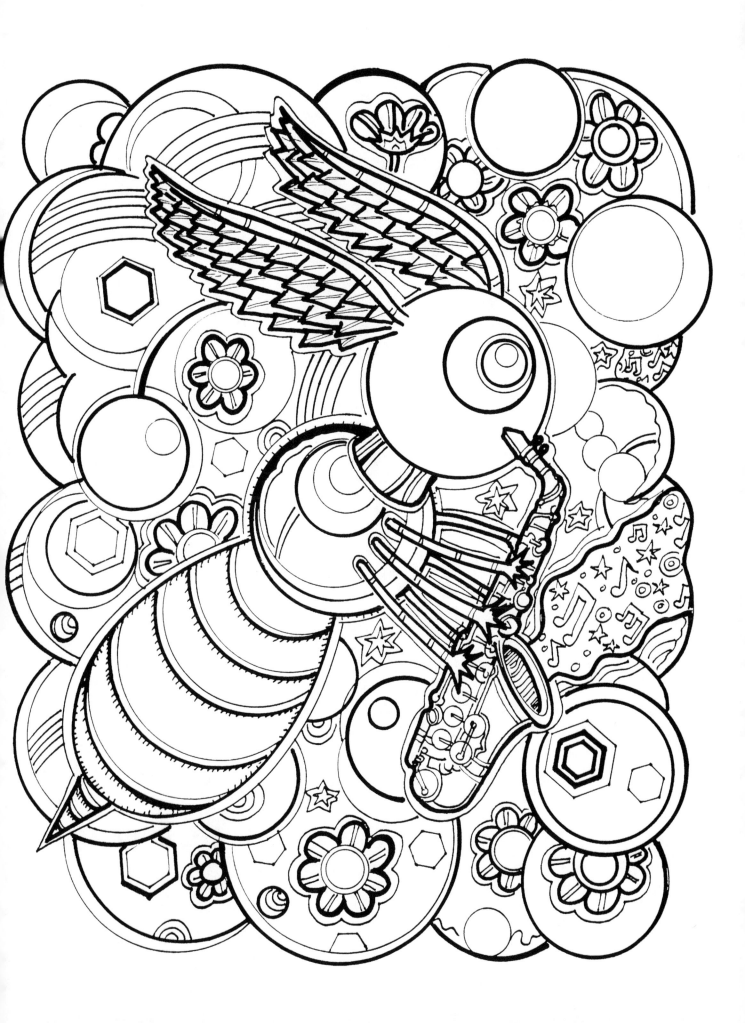

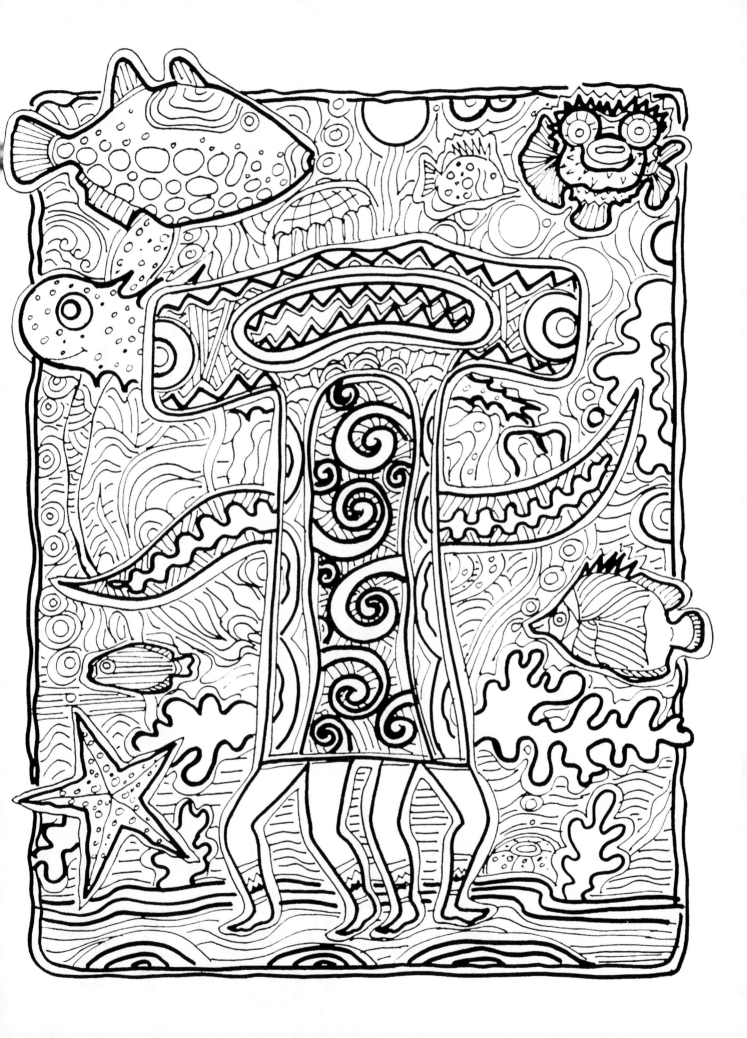

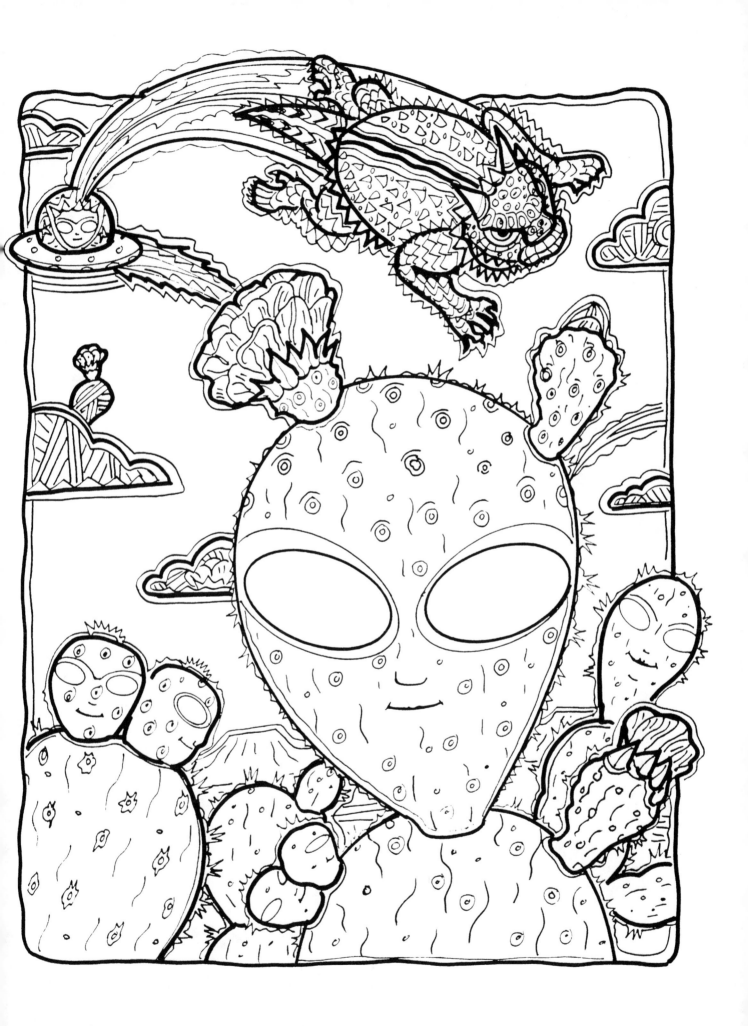

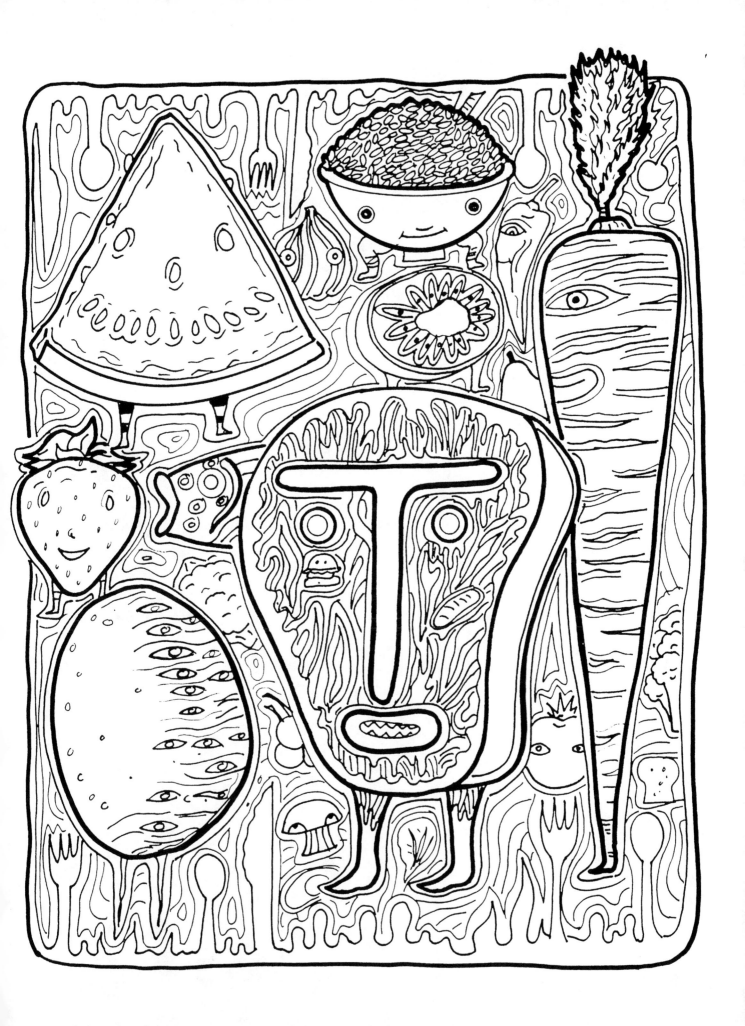

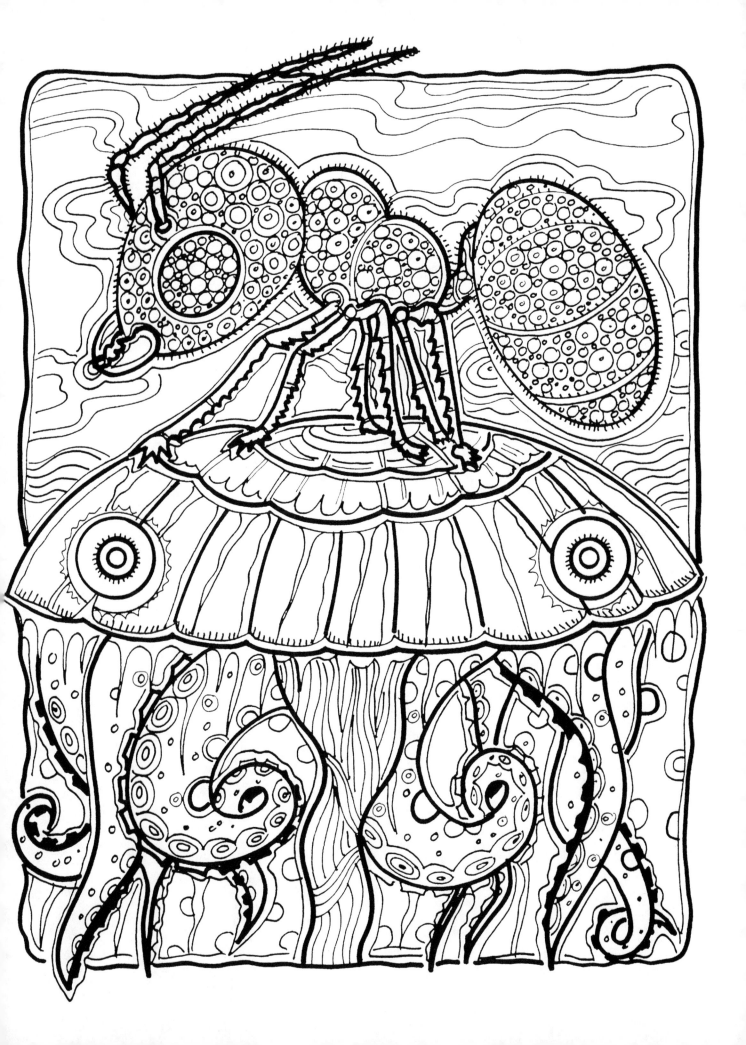

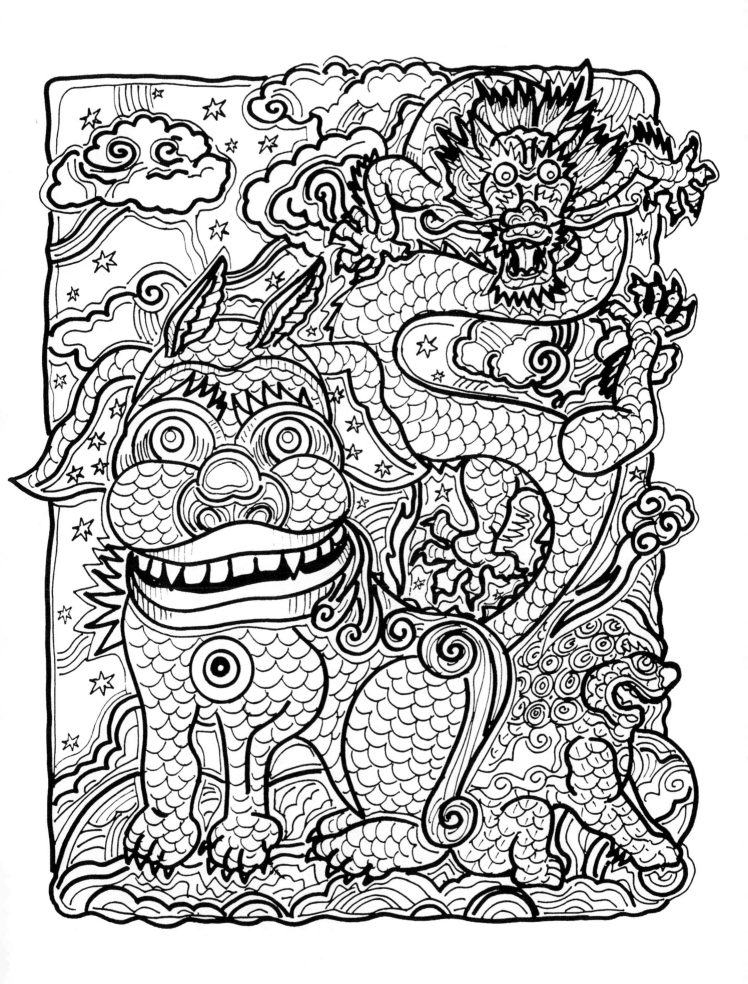

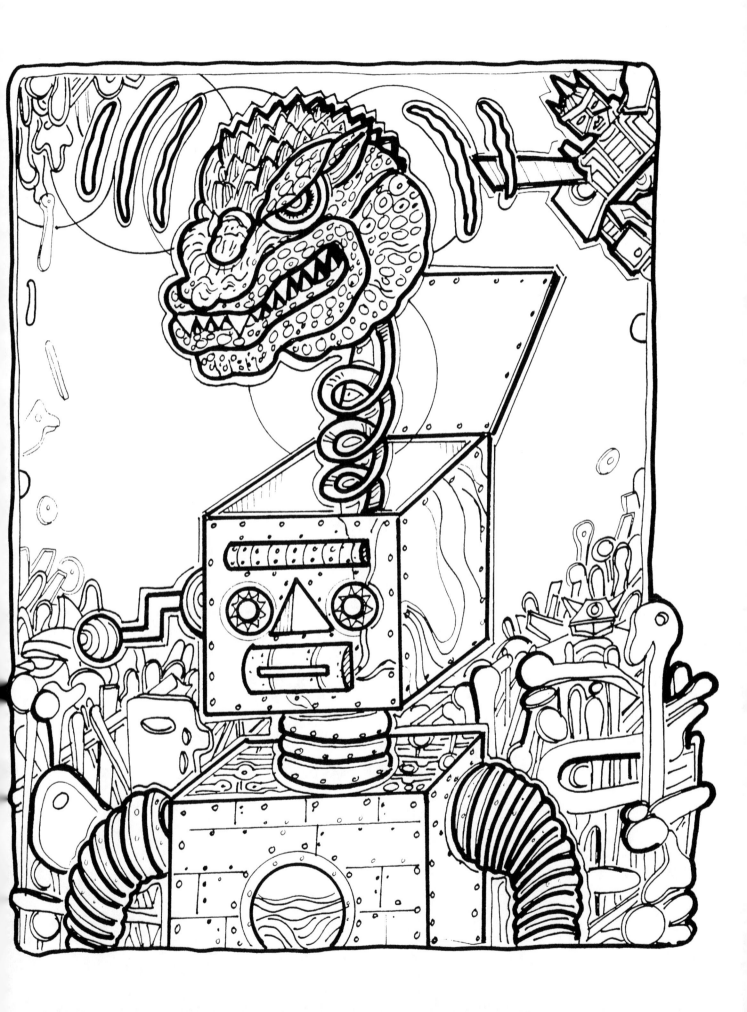

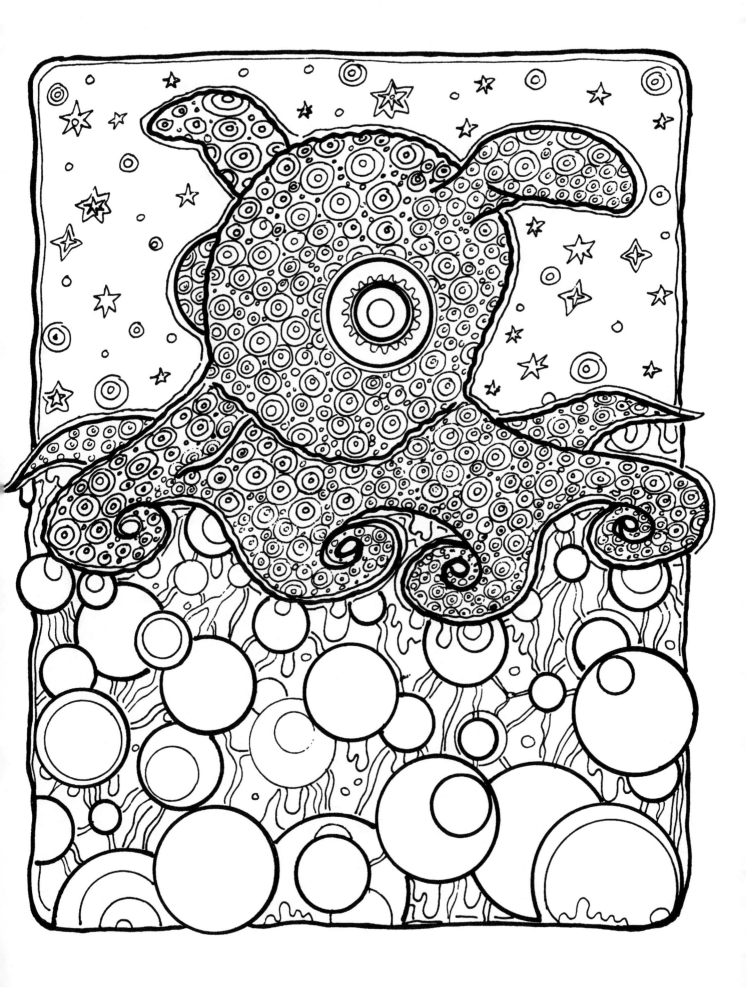

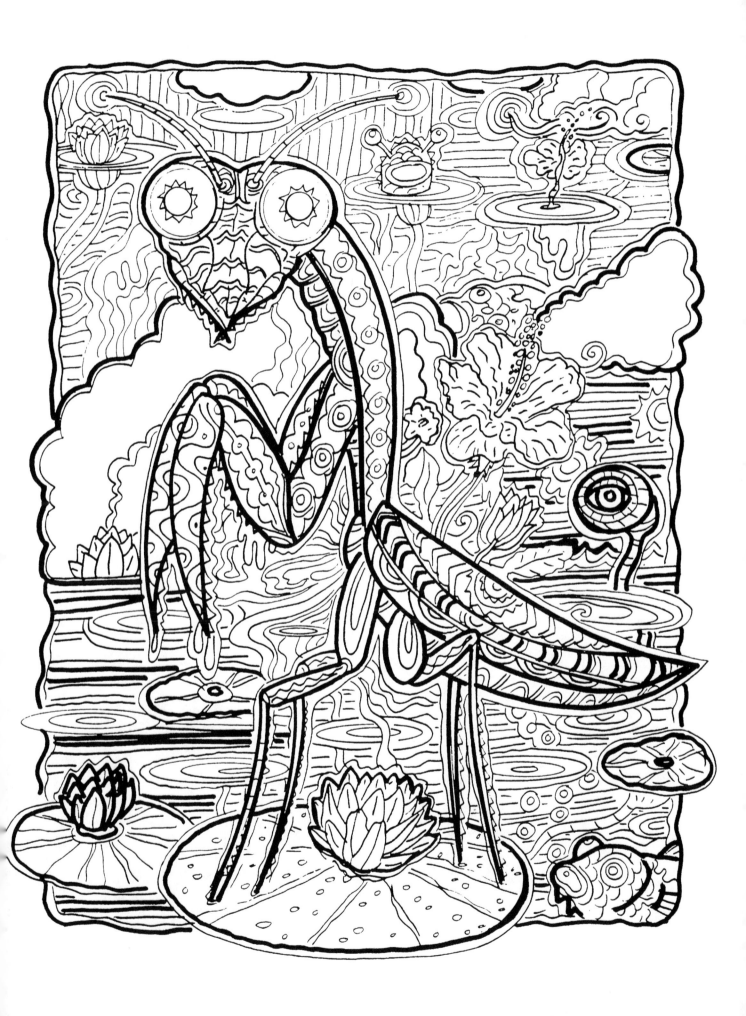

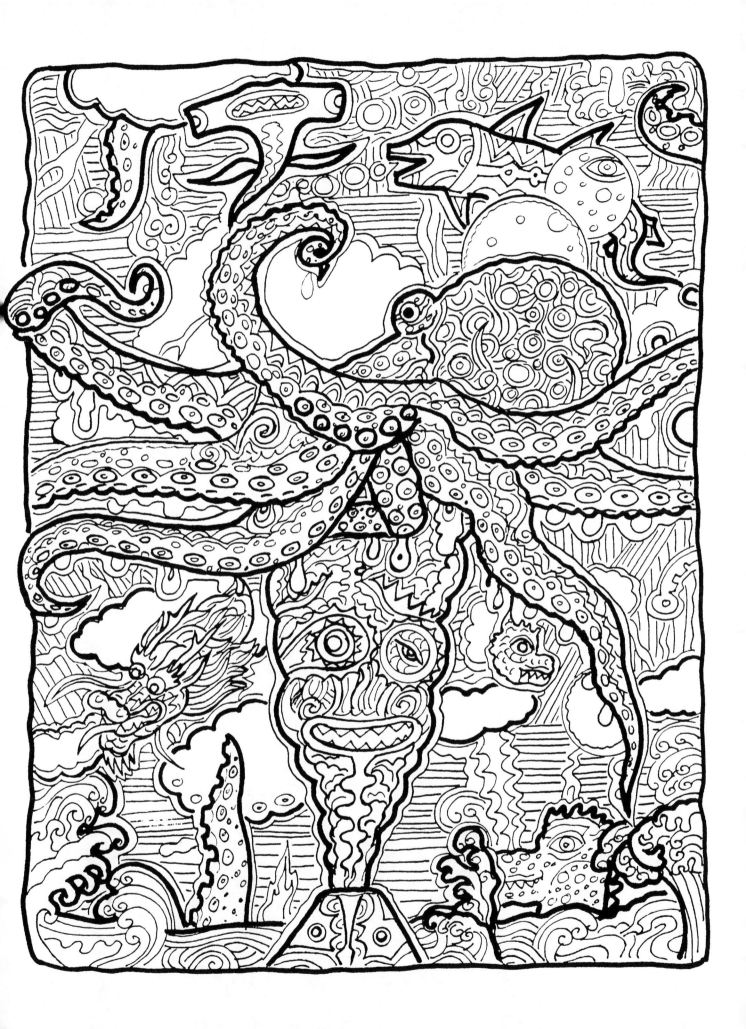

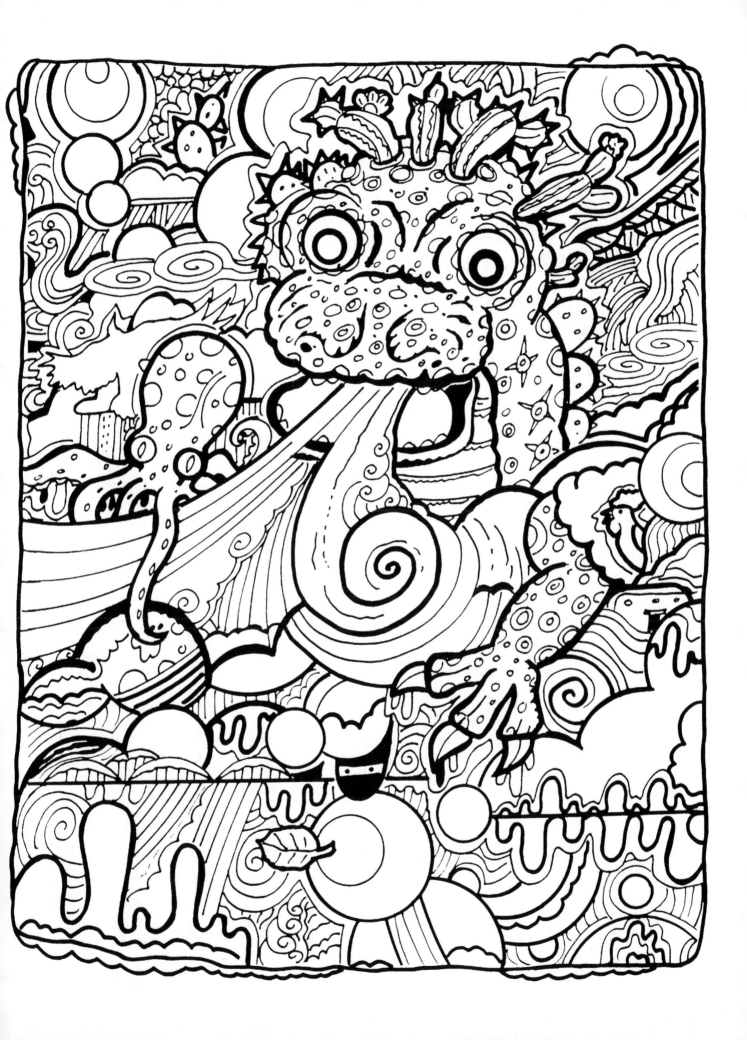

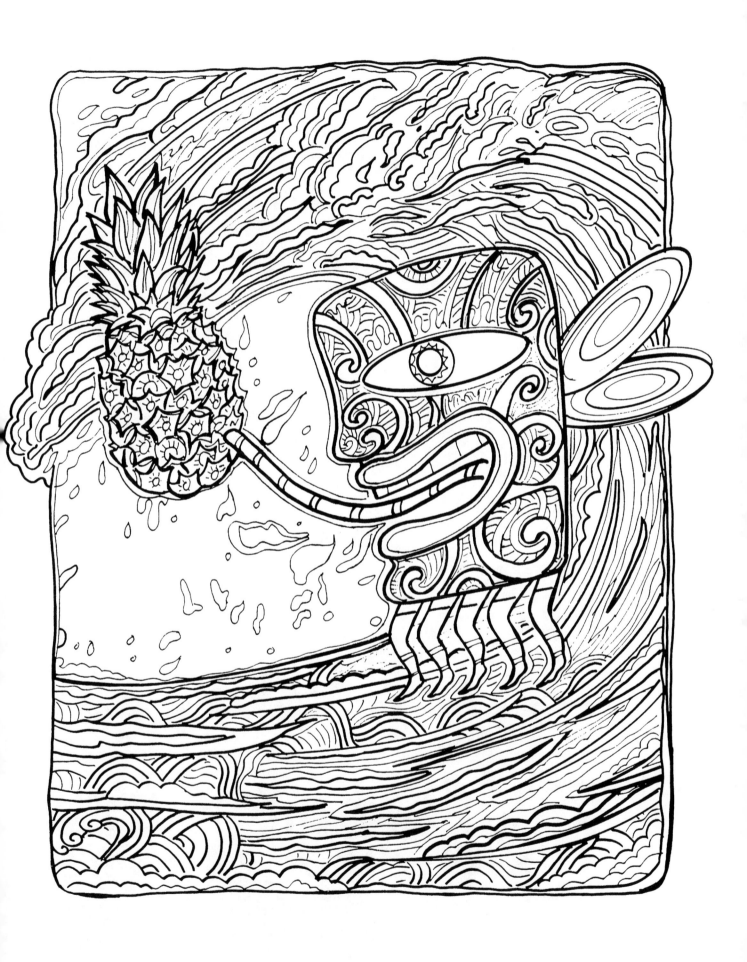

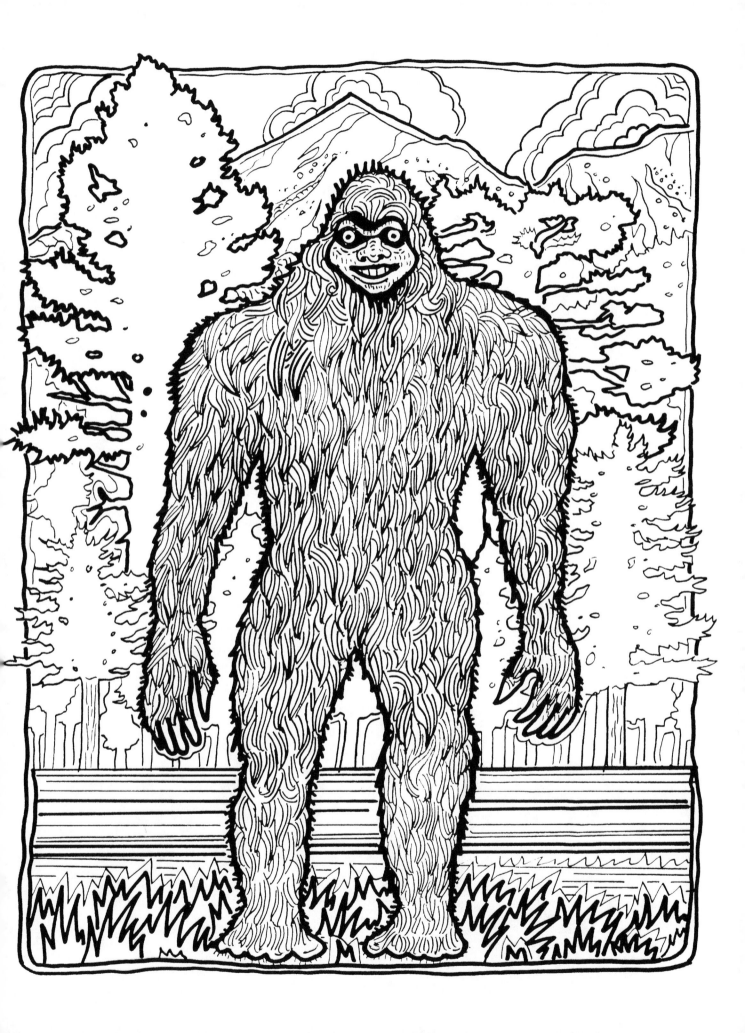

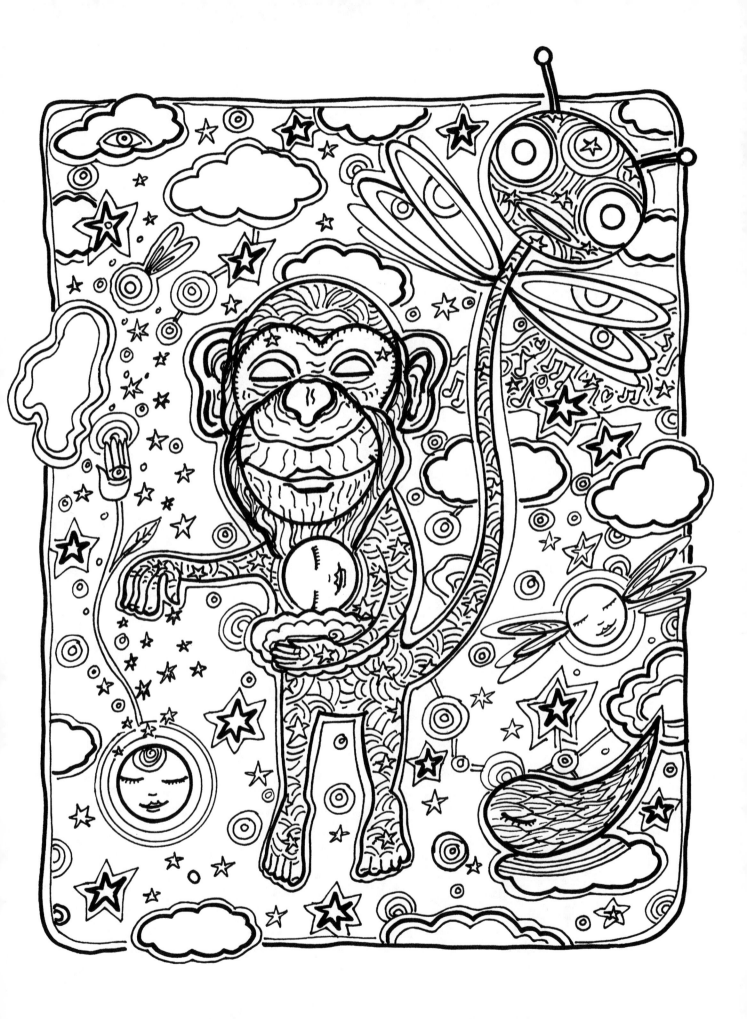

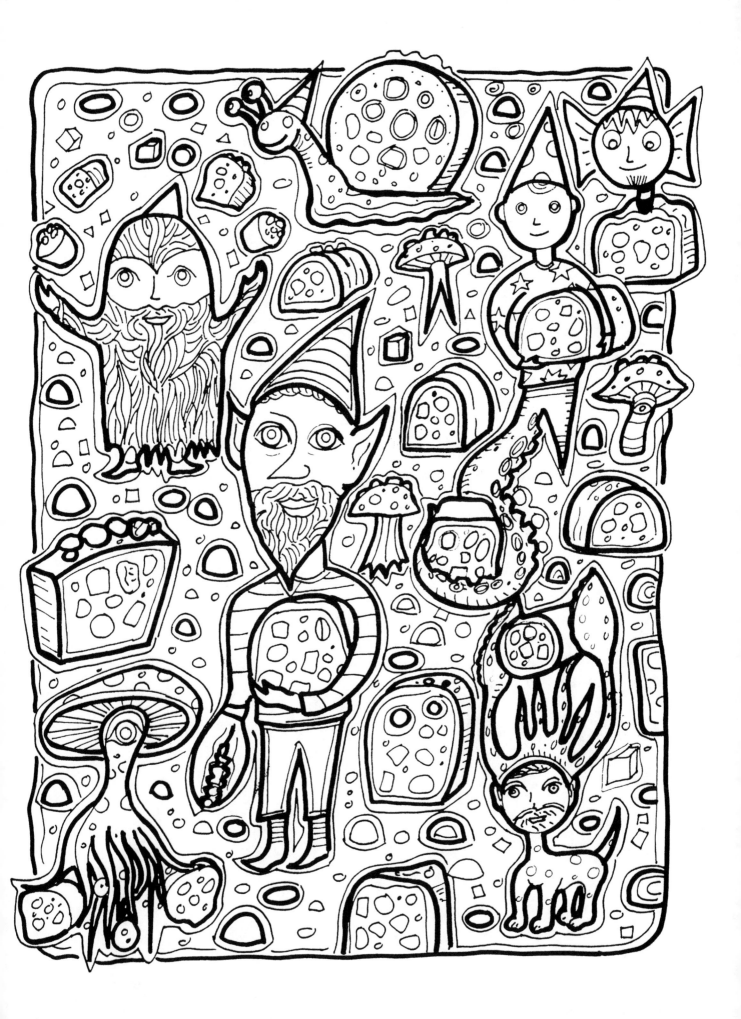

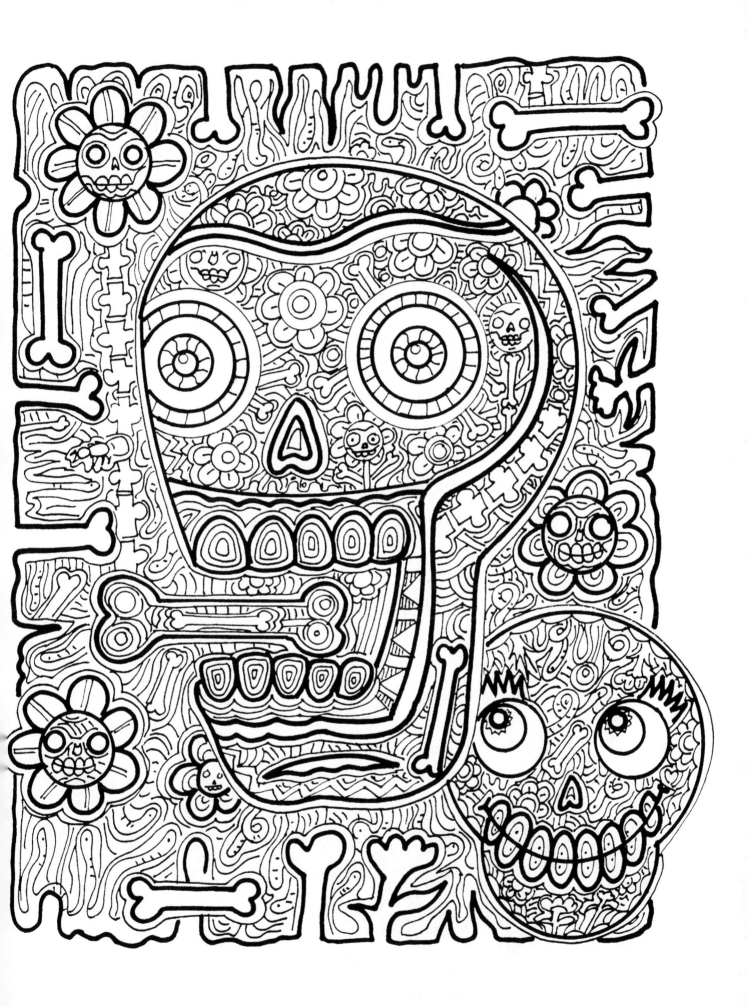

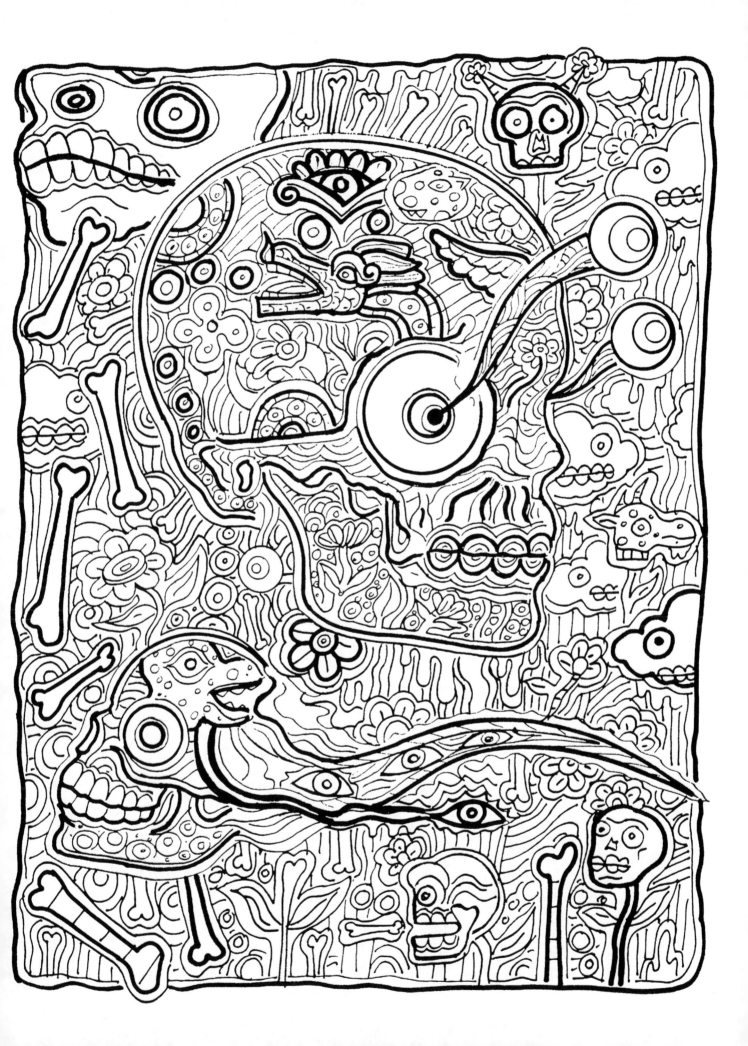

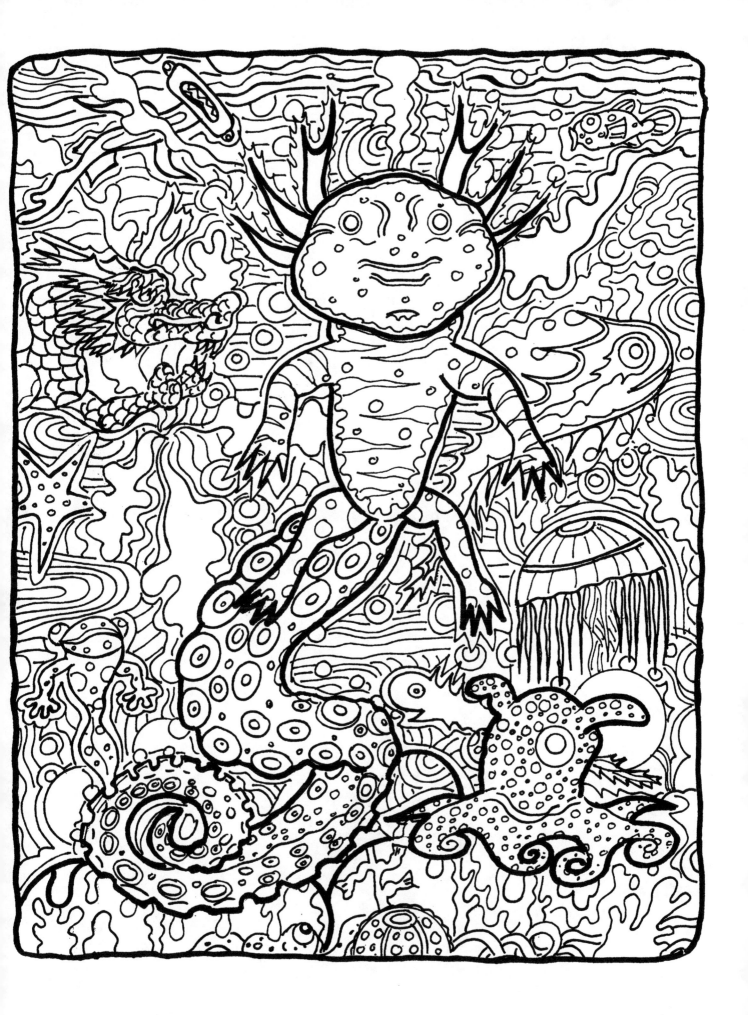

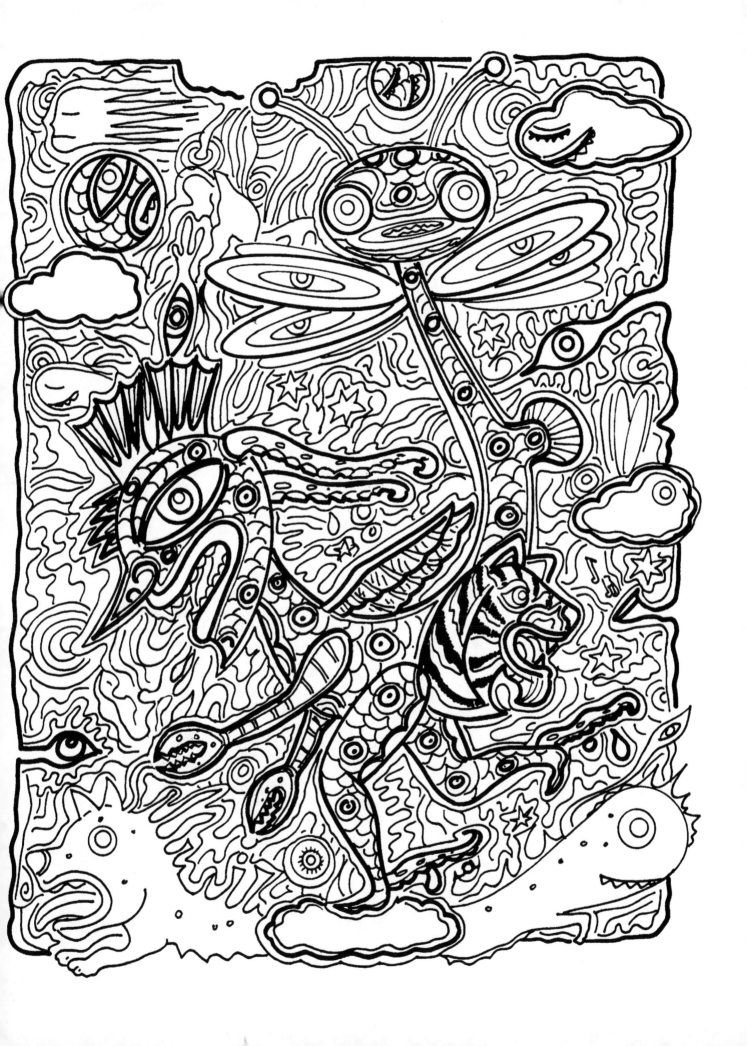

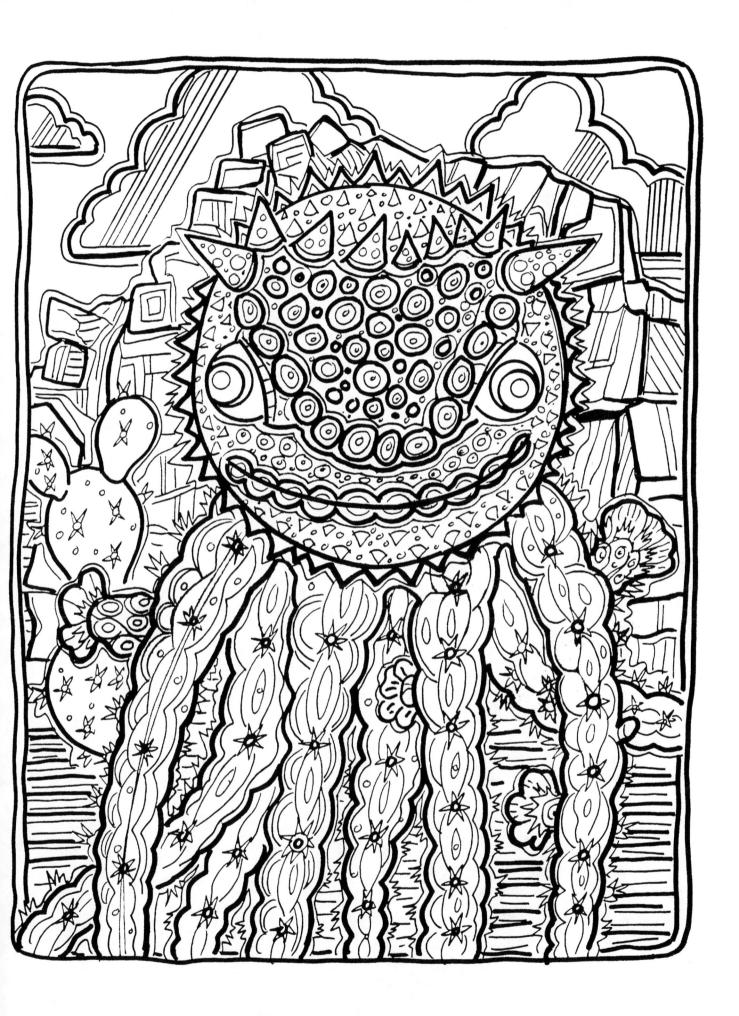

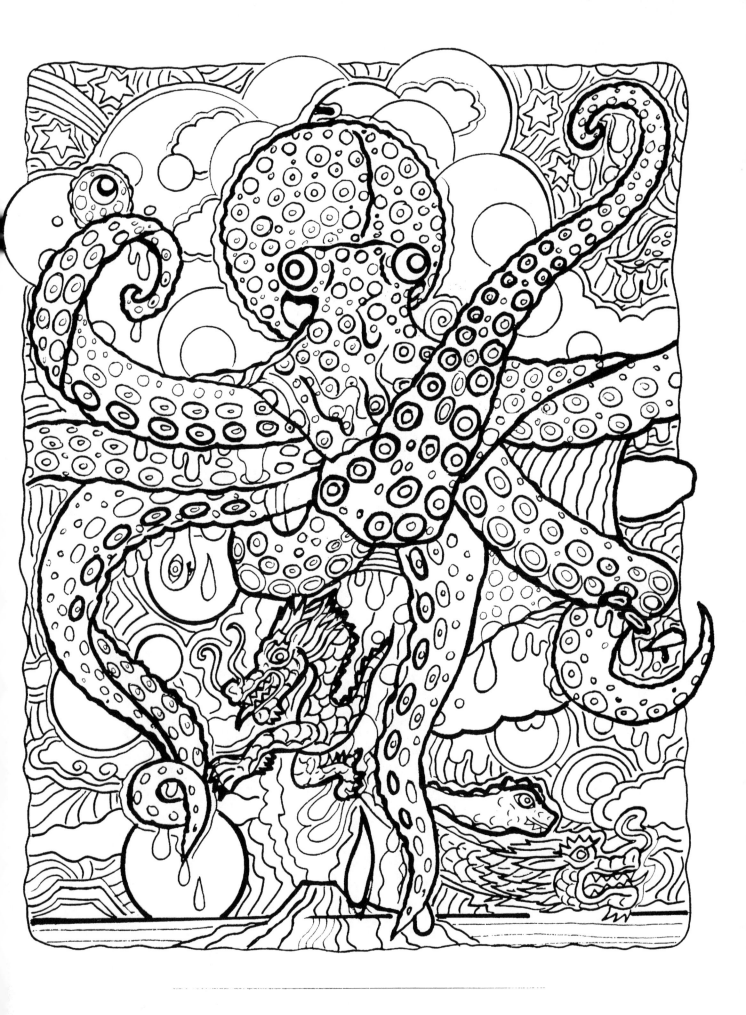

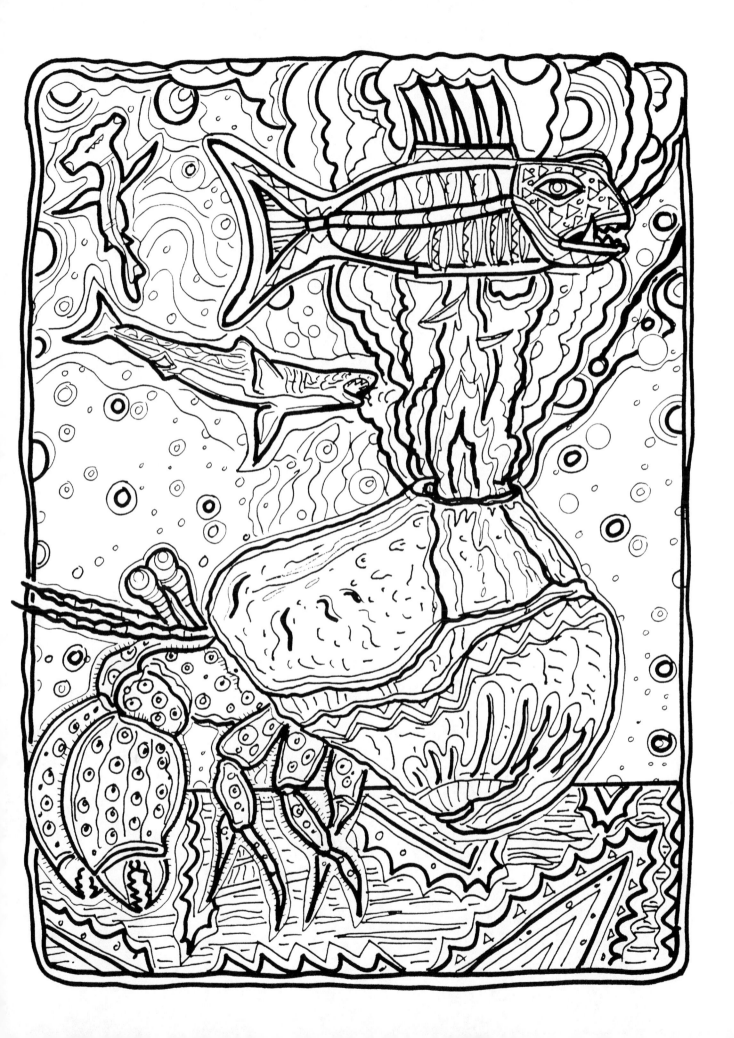

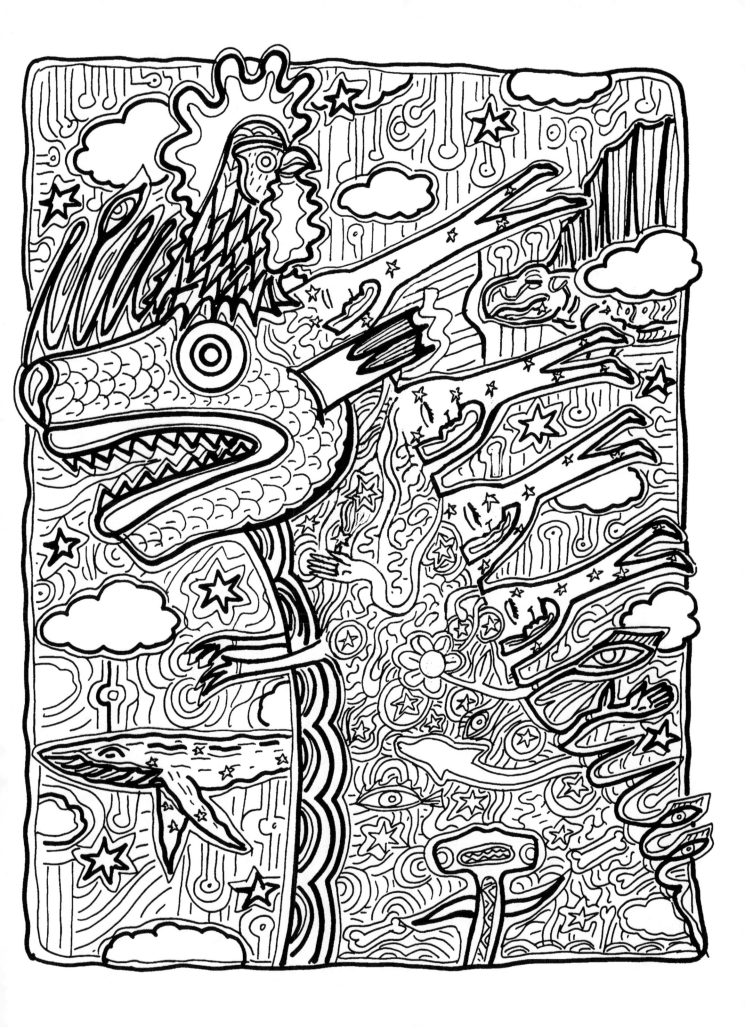

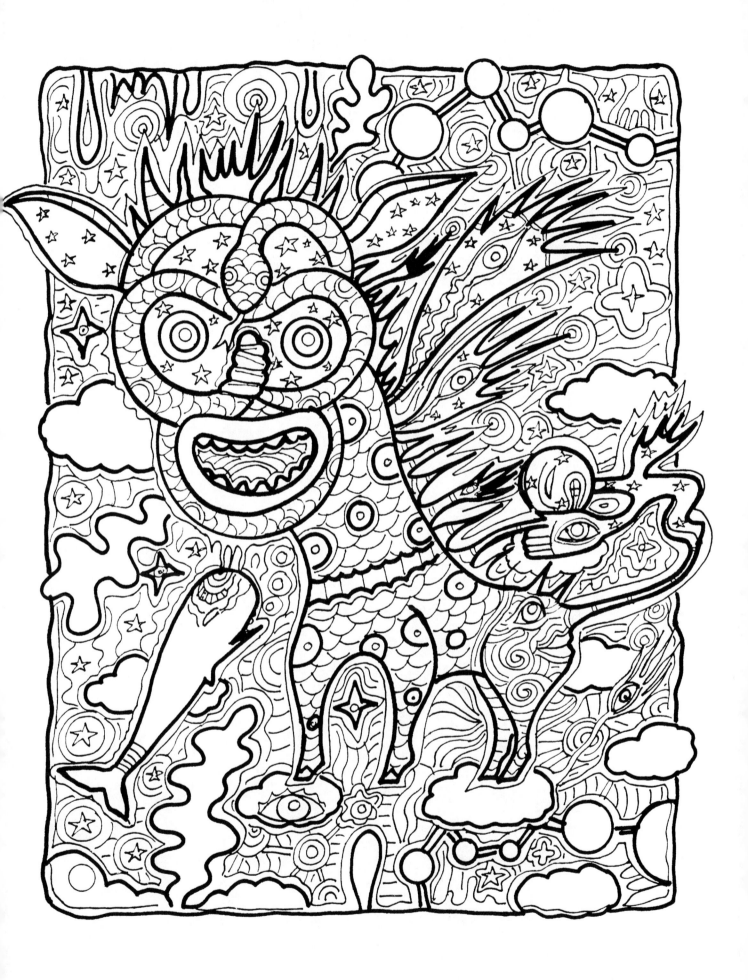

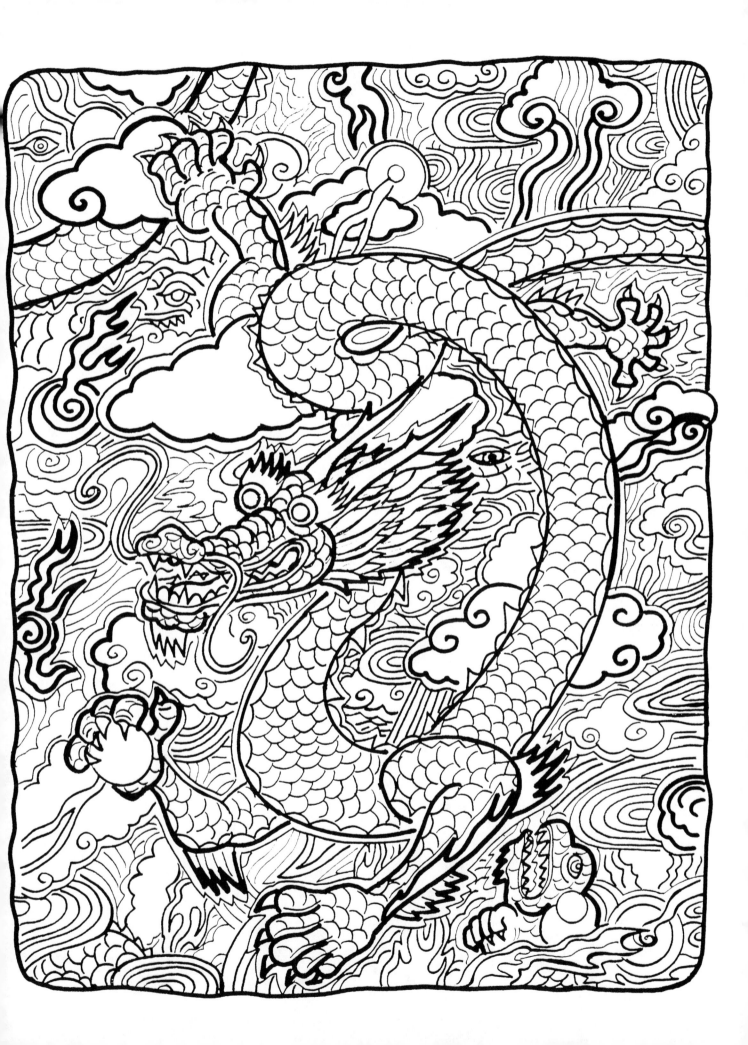

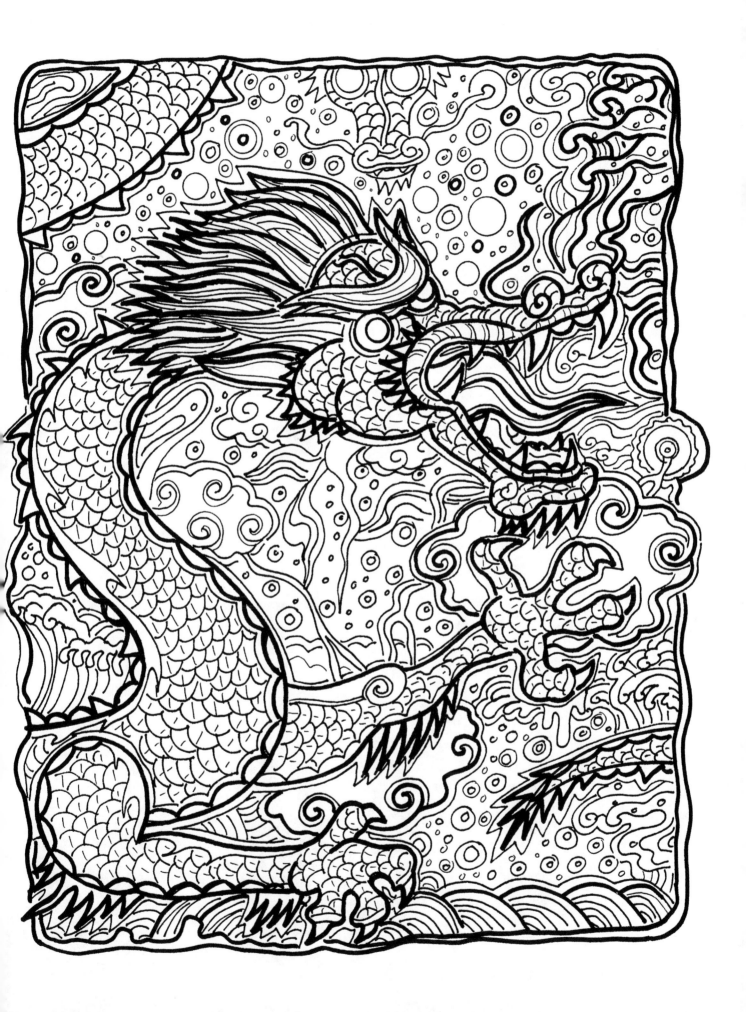

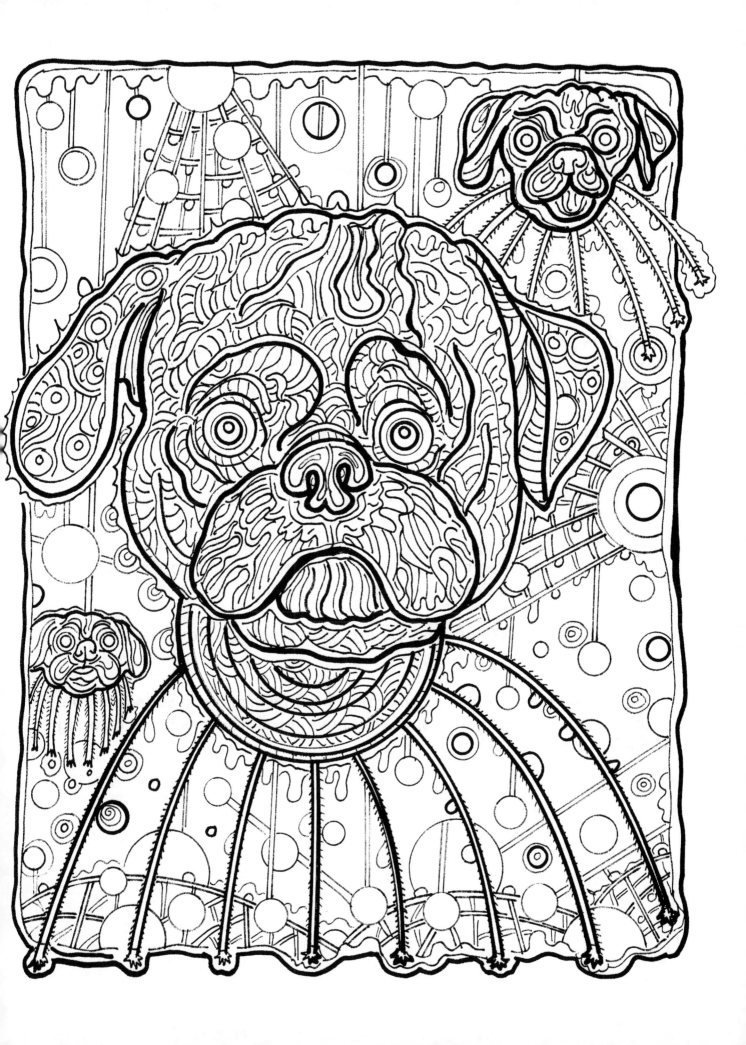

A NOTE FROM JOEL NAKAMURA

PAREIDOLIA: SEEING SUBJECT MATTER IN RANDOM PATTERNS

All the images in this book started this way.

Random patterns—like the example on the adjacent page—were created by taking a piece of crumpled, charcoal smudged paper and rubbing it lightly on a blank sheet of paper.

I looked at each smudge pattern and then drew what I saw in it or emerging from it.

Try it yourself. What do you see in the image to the right? Draw it.

You can work directly on the pattern itself, incorporating it into your drawing, or cover with translucent sketching or tracing paper and work on that to create a drawing that is separate from it.

It's great way to explore and express your creativity. Have fun with it!

P.S. For the purpose of this book, only the drawings are included—not the underlying smudge patterns, so you have no distractions while coloring the images and making them your own.

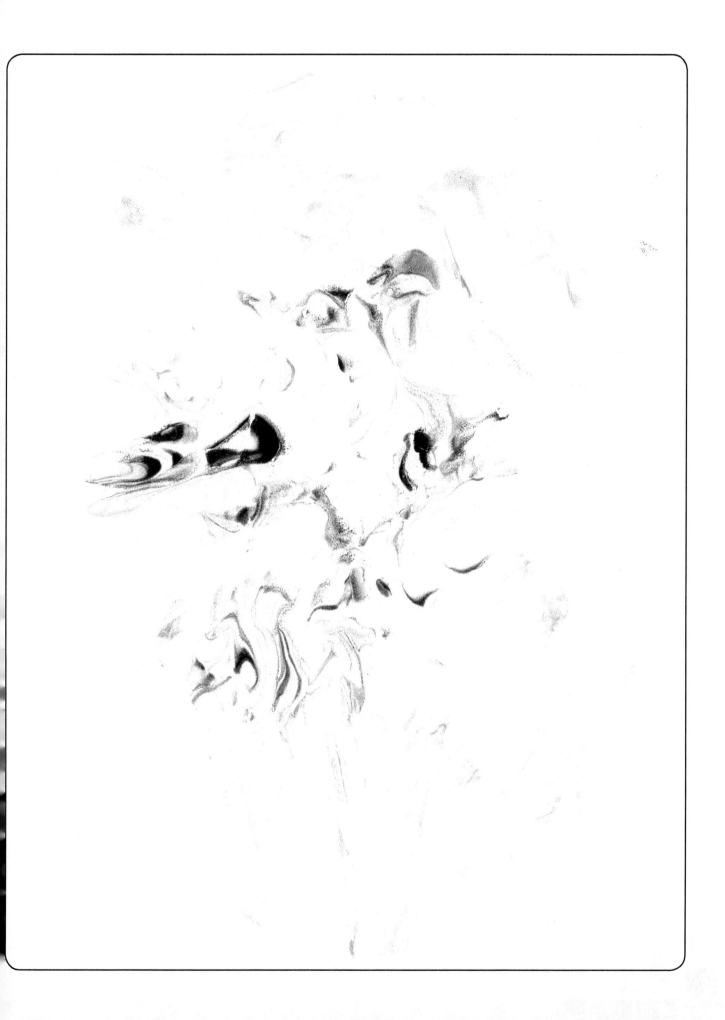